THE LITTLE PLEASURES
of PARIS

THE
LITTLE PLEASURES
of PARIS

Leslie Jonath
Illustrations by Lizzy Stewart

CHRONICLE BOOKS

SAN FRANCISCO

Library of Congress Cataloging-in-Publication Data

Jonath, Leslie, 1964-
 The little pleasures of Paris / Leslie Jonath ; illustrations by Lizzy Stewart.
 pages cm
 ISBN 978-1-4521-4172-5
 1. Paris (France)—Description and travel. 2. Paris (France)—Guidebooks.
3. Paris (France)—Pictorial works. 4. Streets—France—Paris—History—
Pictorial works. 5. Paris (France)—Buildings, structures, etc.—Pictorial works.
I. Stewart, Lizzy, illustrator. II. Title.

 DC707.J655 2016
 914.4'361048412—dc23

 2015015121

Manufactured in China.

Design by Kristen Hewitt

10 9 8 7 6 5 4 3 2 1

Chronicle Books LLC
680 Second Street
San Francisco, CA 94107
www.chroniclebooks.com

For Monique, Sarah, and Miel.

CONTENTS

INTRODUCTION

I lived in Paris as a child and have loved it ever since. While I love visiting historical monuments, museums, churches, and the city's icons of grandeur, it is really the small details that give me the most pleasure, the sort of things that children allow themselves to see and appreciate, but that as adults it's all too easy to overlook: the red flare of spring tulips in the Luxembourg Gardens, the deep purple hue of a cassis sorbet on the Île Saint-Louis, the warmth of roasted chestnuts on a cool fall day, or the swirl of traffic around the Arc de Triomphe. I first noticed these details when I lived there as a child and even now, as an adult, I am charmed by the same small joys and the odd and unusual moments that make Paris so enchanting.

The small, sensual experiences of Paris are everywhere—especially the delights of the season. Spring cherry blossoms floating beneath the Eiffel Tower; the weeping willow trees lining the banks of the Seine; autumn leaves strewn over the steps of Montmartre; a steaming cup

of Angelina's thick hot chocolate warming a winter's chill. In the bakeries and the hidden side streets and the odd little museums, Paris offers some of the most beautiful, quirky, and delicious things to see, do, eat, and smell all year long. "The Little Pleasures of Paris" is a guide to the intimate wonders of this magical city.

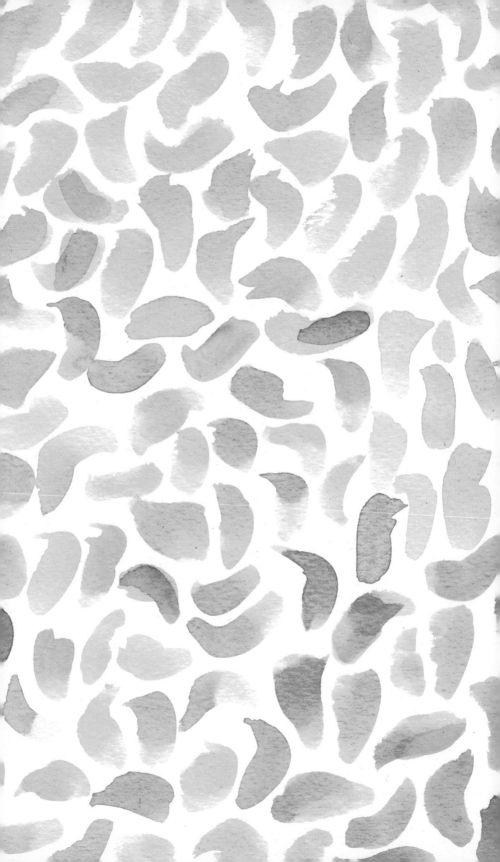

LE PRINTEMPS
(Spring)

The French poet Jacques Prévert once wrote, "Paris is crazy with joy when the spring arrives." The parks come alive with bright green buds and blousy flowers; the fountains sparkle more brilliantly. The streets are con-fettied with chestnut tree petals and performers, boisterous bicyclists, and women wearing beautiful shoes. Restau-rants serve platters of white asparagus and bowls of "moules-frites" (mussels and fries) with glasses of chilled rosé. Parisians gather at cafés to bask in spring's first shimmering light.

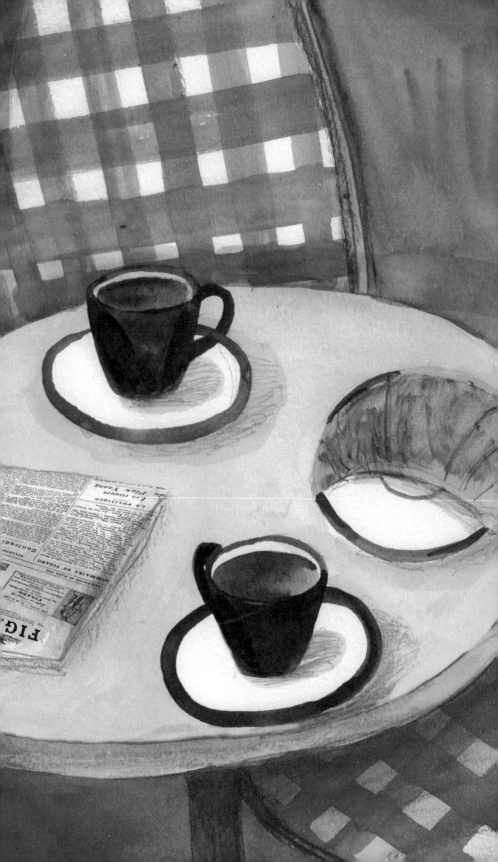

PARISIAN BREAKFAST

In the early mornings, Parisians drink coffee in cafés as the city wakes. The waiters shout out the orders one by one: "Café crème! Un espress! Tartine! Beurre! Confiture! Un croissant!"

Café Les Deux Magots is always full of people—young and old, alone, together, writing, talking, and laughing—or maybe even kissing! Business people in suits, ladies with cat glasses, students with backpacks, families with strollers, children and dogs, and maybe someone reading "Le Monde." This is how the day begins.

PARIS is for DOG LOVERS

Parisian dogs play in parks all over Paris, from the manicured gardens in le Champs de Mars to urban streets in Parc des Buttes-Chaumont to woodsy trails in the Bois de Boulogne and the Bois de Vincennes.

But you don't need to go to a dog park to see Parisian dogs. They are welcome almost everywhere: in hair salons, in department stores, in banks, on the Metro (in dog carriers), on trains, under the table at restaurants, trotting down a fashionable street, or even nestled in their owner's arms. Paris has many fancy dog salons where you can watch the pooches being pampered, lined up on tables, ready for a shampoo, cut, and fabulous 'do.

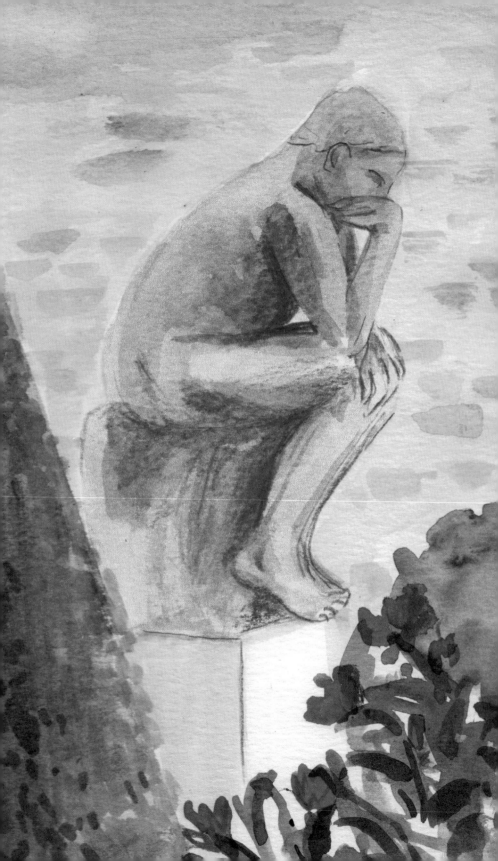

THE THINKER

Le Musée Rodin at the hotel Biron houses the expressive and sensual sculptures of Auguste Rodin, including "The Kiss," a beautiful bronze sculpture of a couple embracing.

The museum's rose-filled garden extends with meandering paths that wind though topiaries and sculpted hedges. There you will find "The Thinker", Rodin's pensive man. Originally named "The Poet" (Le Poète), "The Thinker" was initially commissioned for a doorway for "The Gates of Hell" based on "The Divine Comedy" of Dante.

As Rodin once said, "Nature and Antiquity are the two great sources of life for an artist. In any event, Antiquity implies Nature. It is its truth and its smile."

STAINED GLASS
at SAINTE-CHAPELLE

In the center of Île de la Cité stands Sainte-Chapelle, a beautiful Rayonnant Gothic chapel. "Rayonnant" means "radiant"—a word that perfectly describes the chapel's transcendent, weightless beauty and its splayed, vaulted ceilings. Sainte-Chapelle was originally built by Louis IV as a reliquary to house the Crown of Thorns.

Painted with scenes of saints and hung with tapestries, the dark blue walls and ceilings glimmer with stars. In the nave, stained-glass windows glow in gorgeous shades of deep red, cerulean blue, and brilliant yellow. When the sun hits the Rose Window, the chapel becomes luminous.

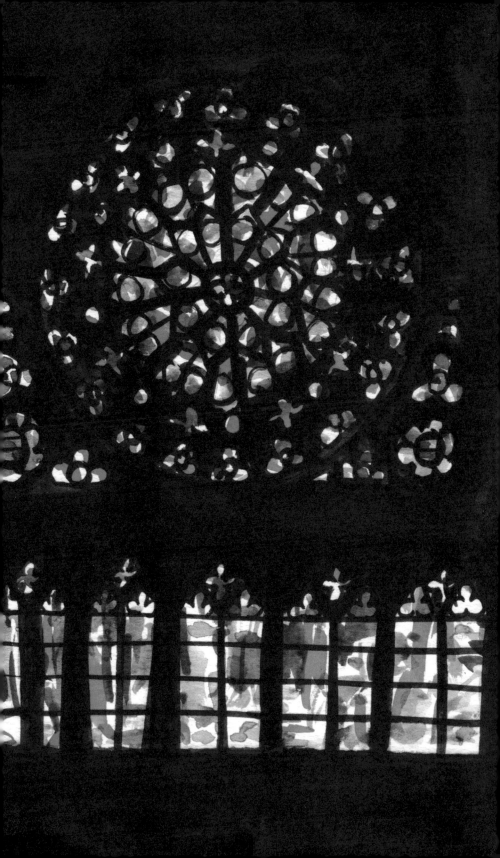

THE FLOWER and
BIRD MARKET

Not far from Sainte-Chapelle, on Place Louis Lépine, Le Marché aux Oiseaux et aux Fleurs blooms year round. The oldest flower market in the city, the glass greenhouse overflows with roses, tropical orchids, spiked cacti, and curling vines.

On Sundays, the square turns into a bird market filled with squawking, chirping, singing parrots, parakeets, canaries, chicks and chickens, roosters, and African finches that flap their vibrantly colored wings. There you will find birdcages made in classical, modern, and beaux arts styles, and teeny-tiny birds nests made for teeny-tiny birds.

MARBLES in
LE CHAMP de MARS

*T*he Eiffel Tower is sometimes referred to as La Dame de Fer, which means "the iron lady." Built in 1889 for the World's Fair, it still stands as the tallest monument in Paris. From the top you have a stunning panoramic view of the whole city.

If you look straight down from the top of the tower you may see the tiny figures of children dressed in blue and white uniforms playing in Le Champ de Mars. There are many schools in the neighborhood, and during recess the kids play marbles. The children crouch in circles and take turns rolling marbles with the goal of hitting their opponent's trove. Winner takes all.

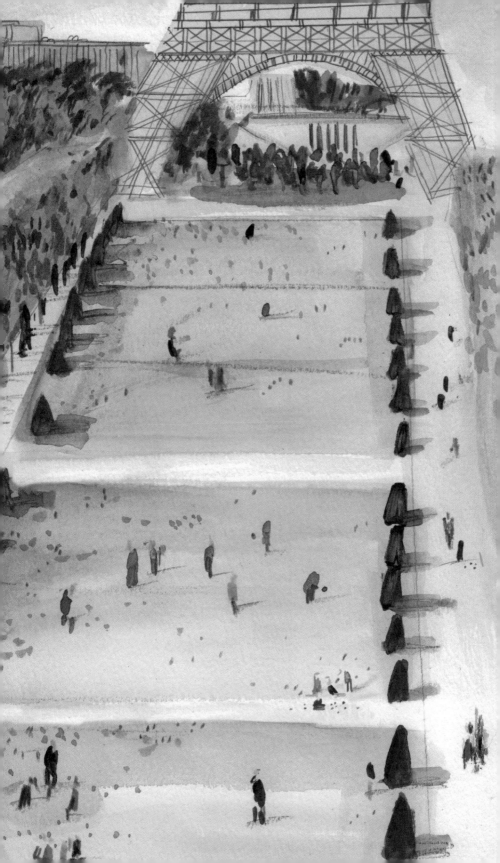

LES ÉCLAIRS

A delicate oblong cream puff piped with custard, the éclair was once a favorite of French royalty.

Most boulangeries make éclairs in the traditional flavors of chocolate, vanilla, coffee, and caramel, but at *L'Atelier de l'Éclair,* modern flavors delight, from melted chocolate and honey to raspberry lemon and passion fruit. "Éclair" is the French word for "lightning"—a name that some people attribute to the way the dessert flashes when coated with icing.

LES BOUQUINISTES

The green box stalls of "les bouquinistes," Paris's secondhand booksellers, line the Seine from the Pont Marie to the Quai du Louvre, from the Quai de La Tournelle to the Quai Voltaire. There you will find racks of faded hardcover books and curled paperbacks, a biography of Marguerite Duras and the poems of Victor Hugo, campy pictures of old-time cancan dancers, antique maps, turn-of-the-century postcards, and packets of handwritten letters whose words and sentiments now belong to you.

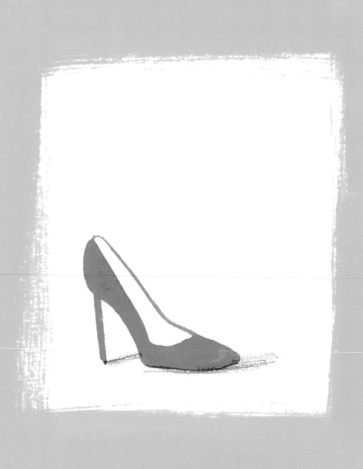

PARIS FASHION

*E*very spring, fashion-show tents pop up in the gardens of the Tuileries. Inside, models strut and spin down the runways in pin-straight skirts, flouncy dresses, and wide-brimmed hats, teetering in elegant shoes.

Parisians love shoes. At Galeries Lafayette, the entire bottom floor is devoted to shoes in all shapes, colors, and sizes in leather, leopard skin, brushed suede, and red patent leather: mules, flats, wedges, platforms, ballet slippers, sneakers, boots, booties, and impossibly tall stilettos.

CHAGALL'S
FLOATING LOVERS

A grand staircase in the Paris Opera House leads to the theatre with the red velvet seats. If you look up you will see twelve panels plus a center panel painted by Marc Chagall that evoke composers and their operas, including Bizet, Mozart, Verdi, and Wagner. In the richly colored panels angels, flutes, fiddlers, mystic creatures, and embracing lovers float among places of the imagination and Parisian monuments. It was said that for Chagall, "love was the force that bound together and moved everything in the universe, whose creatures and objects were part of a total motion without top or bottom, gravity or resistance."

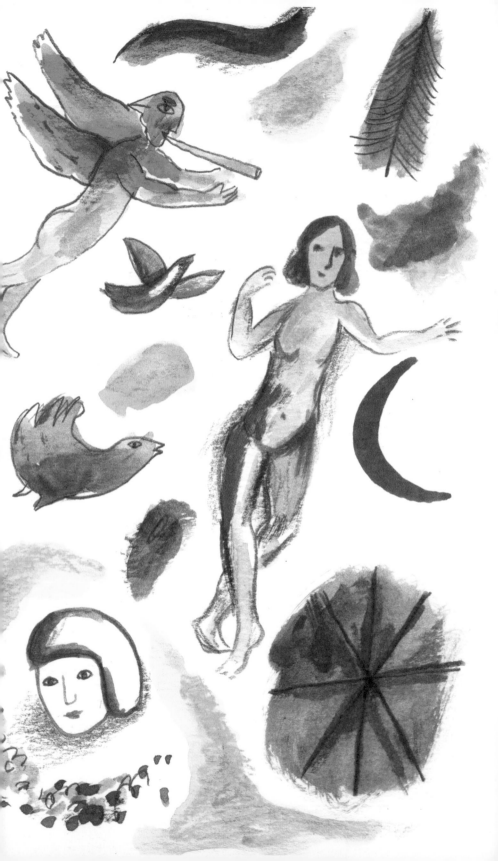

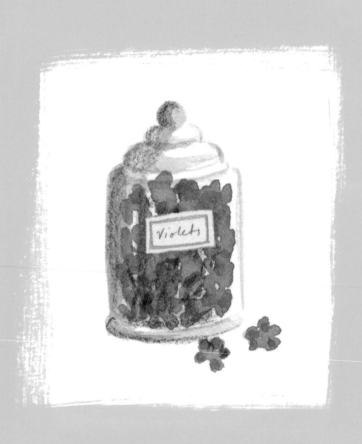

CANDIED VIOLETS at À la MÈRE de FAMILLE

Paris's oldest sweet shop, À la Mère de Famille, opened on the Rue Faubourg Saint-Honoré in 1761. The shop's patterned floors and antique lights evoke nostalgia for a bygone age. Every inch of space is packed with exquisite boxes, glass jars, and containers of bonbons, fruit confits, caramels, marshmallow ropes, glazed chestnuts, honeyed orange peels, chocolates, and miniature marzipan fruits. Candied violets, a sugary delicacy, were first concocted in the nineteenth century and remain a delicious sign of spring.

L'ÉTÉ
(Summer)

As the summer days grow warmer, couples stroll under the shade of leafy avenues, and friends gather to chat on park benches. Picnicking families and sunbathers line the banks of the Seine. Buses roll down the avenues, filled with photo-taking tourists. All over the city, people nap in parks and eat ice cream. In August, many Parisians leave "en vacances"; the city is warm and quiet.

SUMMER PLEASURES in the LUXEMBOURG GARDEN

In the summer, the Luxembourg Garden is full of small pleasures: families launch miniature sailboats in the lake, guiding the colorful boats with big sticks; under the plane trees, children ride small, shaggy ponies and giggle at the puppet theater.

The gardens were created by Queen Marie de' Medici to remind her of her childhood home in Florence: an orchard filled with old apple trees, an apiary, and strolling paths where you can hear the clacking of the metal balls as people play pétanque. All over the park people sit in green metal chairs watching, reading, and sleeping in the gentle breeze.

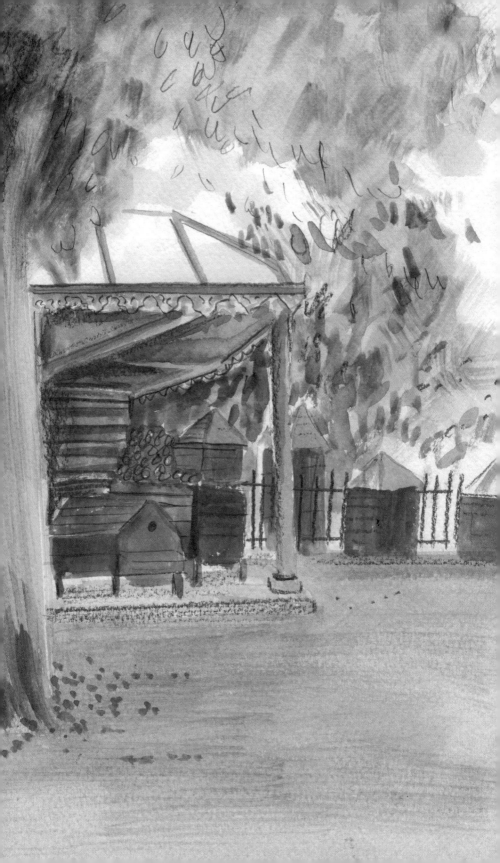

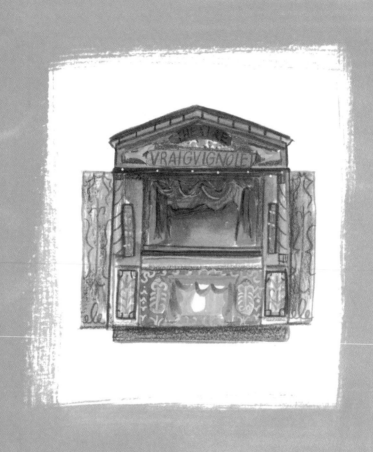

LES MARIONETTES

To attract patients during the French Revolution, a French dentist started performing puppet shows in front of his dentist chair. Created for a mostly working-class audience, the shows were satires that featured characters whose struggles mirrored the audience's own. The most popular of these shows was Guignol, named for the main character, who was poor but also clever and brave and whose victories represented the triumph of the people. The show was so popular that the dentist gave up dentistry to become a professional puppeteer, and it is performed to this day by companies founded by his descendants. While today's audiences are mostly children, the puppet show maintains a revolutionary spirit.

LES BATEAUX MOUCHES

*P*aris has 37 bridges that cross the Seine. From Pont des Arts, one of the four pedestrian bridges, you can see the arches of the Pont Neuf and many others that span the river. Le Pont Neuf translates to "The New Bridge" though it is, in fact, the oldest bridge in Paris. Farther down are Pont d'Arcole, Petit Pont, Pont Notre Dame, Pont Saint-Michel, and Pont au Change.

No matter what the bridge, if you look straight down at the water you will see the long, feathered wakes of barges, houseboats, and open-air tour boats as they navigate the river's waterways.

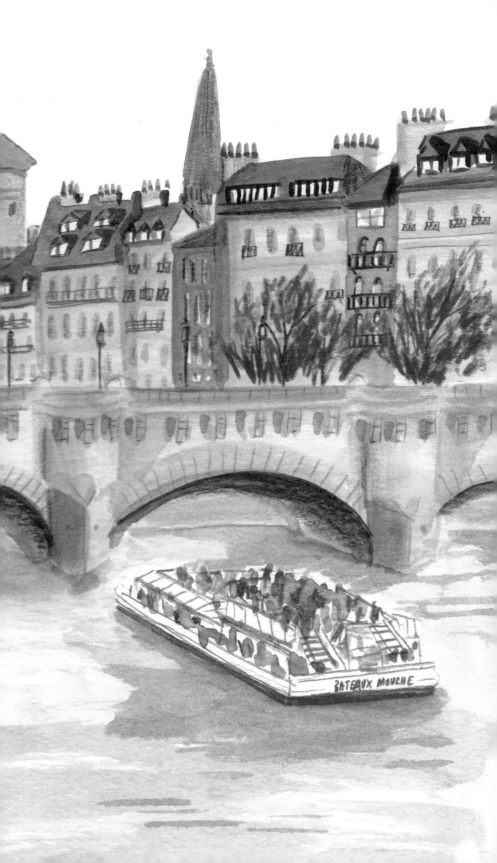

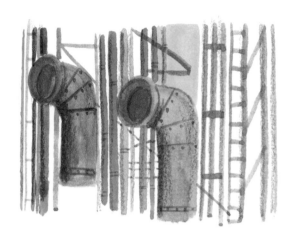

INSIDE-OUT at the CENTRE POMPIDOU

Set in the middle of Le Marais, Centre Georges Pompidou is home to the Public Information Library and the National Modern Art Museum. Also known as Beaubourg (the name of the neighborhood), the structure itself is a work of art featuring an exoskeleton of brightly colored tubes coded by function: green pipes for plumbing, blue ducts for temperature, yellow-encased wires for electricity, and red for fire extinguishers and safety features. Even the elevators are on the outside of the building—you can see visitors in the transparent tubes, ascending the height of the building.

THE
STRAVINSKY FOUNTAIN

Sixteen quirky kinetic statues make up the Fontaine des Automates, which sits in the Place Stravinsky between the Centre Pompidou and the Church of Saint-Merri. Completed by Jean Tinguely and his wife, Niki de Saint Phalle, it honors the work of the composer Igor Stravinsky. Spiral metal wheels roll; water spouts from an elephant's trunk; a white serpent twists in a corkscrew; a heart spins around itself; and a pair of giant red lips spits directly at the crowd.

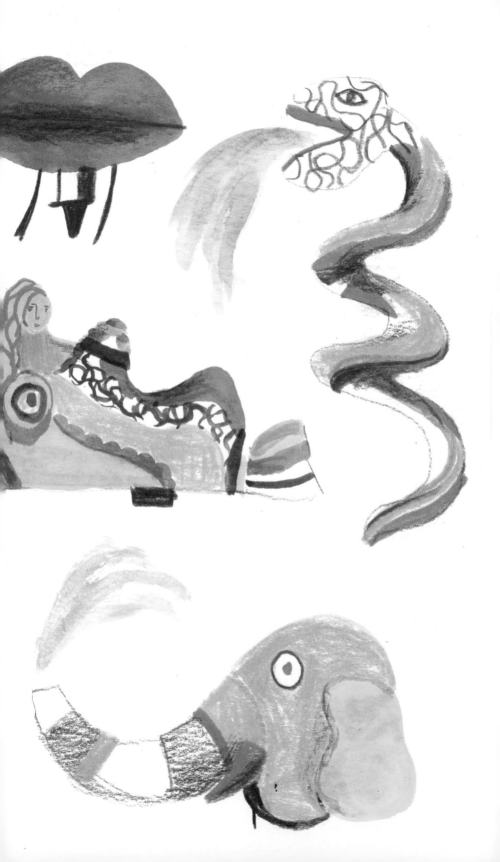

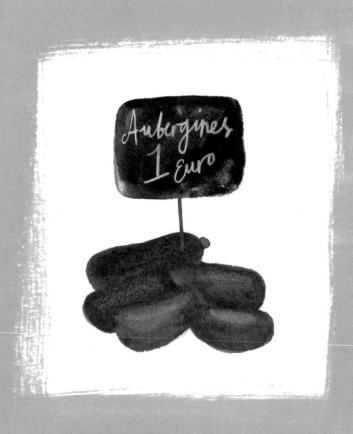

LA RUE MOUFFETARD

*I*n the summer, the market stalls on **La Rue** **M**ouffetard overflow with fruits and vegetables: mounds of deep-red tomatoes and peppers, purple-black eggplants, and rosy peaches individually wrapped in tissue paper—all labeled in cursive on miniature chalkboards. **R**abbits, ducks, pheasants, and other small animals hang upside-down in the butcher shops, and the charcuterie windows are filled with pâtés and sausages. At dusk, the cobblestone streets fill with the savory scents of meats grilled on spits and rosemary roasted chicken, along with the sounds of clinking glasses.

META MONA LISA

You could spend a lifetime looking at art in the Louvre, wandering through the museum's massive collection of paintings, sculptures, jewels, ancient objects, and miniature porcelain figures. Nevertheless, many tourists head directly to the "Mona Lisa." You will know you have found the painting when you encounter a massive crowd hovering in front of a wall snapping countless photos. It might be hard to see her through the hordes, but when you do catch a glimpse of her, her intimate gaze will feel as if it is only for you.

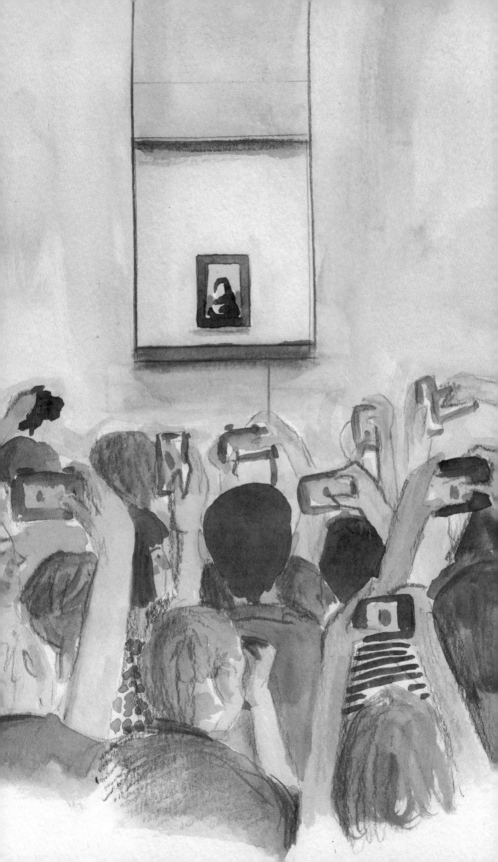

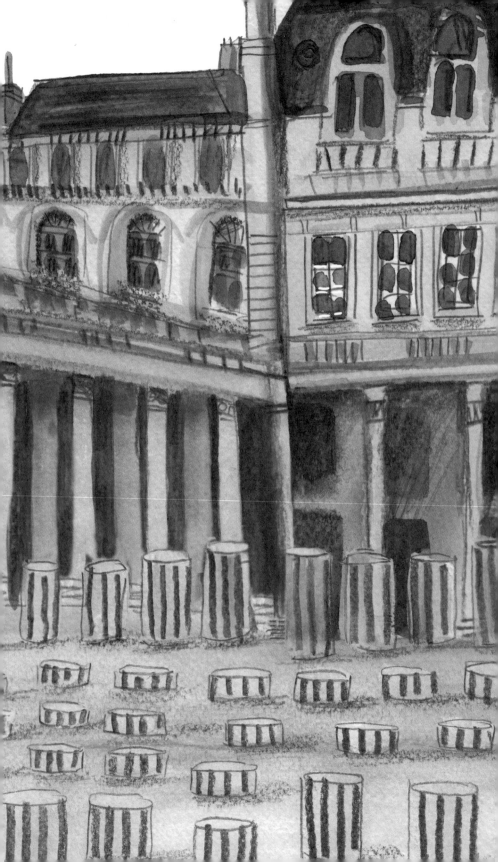

THE SILVER REFLECTIVE BALLS at LE PALAIS ROYAL

Surrounded by elegant arcades and tree-lined "allées," the Jardin du Palais Royal features a large circular pool and fountain. Le Palais Royal has a long history of hosting artists and intellectuals, including Honoré de Balzac, Jean Cocteau, Henry James, and Colette.

In the courtyard, people often sit or stand on the black-and-white-striped posts installed by the French artist Daniel Buren or find amusement staring at their distorted reflections in the mirrored spheres designed by Pol Bury.

A PICNIC at
LA PLACE des VOSGES

La Place des Vosges is one of the oldest squares in Paris. The writer Victor Hugo lived on the square for sixteen years, and his apartment is filled with objects and oddities: an eclectic array of Flemish tapestries, Delft tiles, and Japanese porcelain, along with homemade furniture that he fashioned from parts of old chests. The museum also contains a collection of antique memorabilia: inkwells, charms, maps, and more.

La Place des Vosges is a lovely place for a picnic. You can recline on the grass or share a sandwich on a shaded bench.

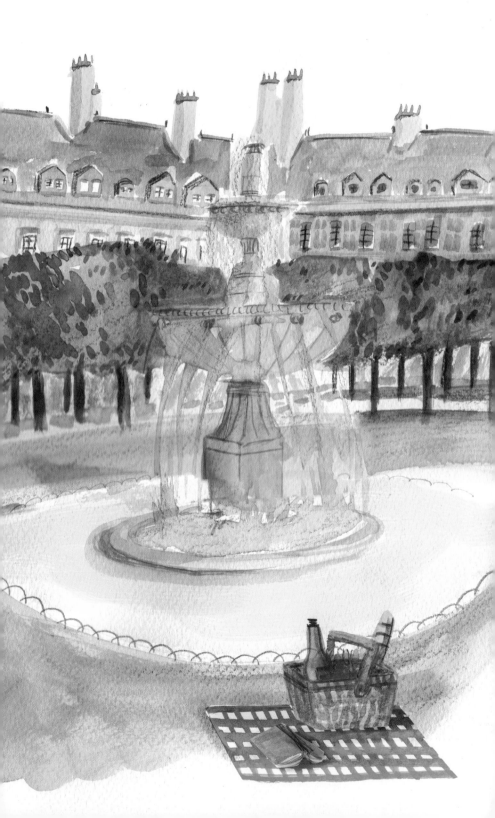

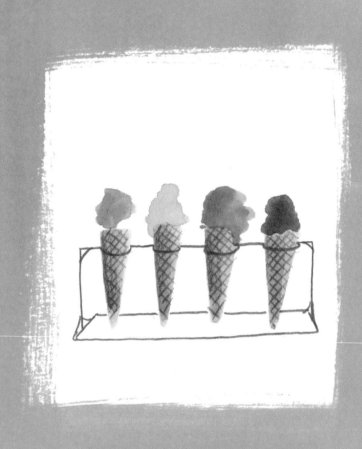

ICE CREAM on
ÎLE SAINT-LOUIS

Saint-Louis, a tiny island in the middle of the Seine, feels like a small village with narrow cobblestone streets, ornate iron balconies, and artisanal cheese, wine, and flower shops. In the summer, a long line forms outside Glacier Berthillon as dozens of customers wait in anticipation of tasting the shop's seasonal ice creams, sorbets, "vacherins" (meringues with fruit and whipped or ice cream), bombes, and other frozen desserts. The chalkboard menu list is as long as the line, including:

SAVEURS:

Glace:	Sorbets:
Vanille	Abricot
Lavande	Cassis
Nougat au Miel	Fruit de la Passion
Noisette	Myrtille
Pistaches	Pêche de Vigne
	Framboise
	Fraise des bois

FÊTES de la MUSIQUE

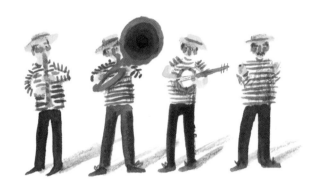

The citywide summer music festival called "Fêtes de la Musique" is held on the summer solstice. The word "fête" ("festival") sounds like the word "faites" ("make")—so the double entendre of the festival's name is true to the festival's goal, which is for everyone everywhere to make music. On the longest day of the year, the city erupts into a free concert: an opera at Le Palais Garnier, jazz in Montmartre, hip-hop at Bercy, a small Yiddish band in a bar, a violin duo on a balcony. If you are lucky, you might even see a group of elementary school children singing "La Marseillaise."

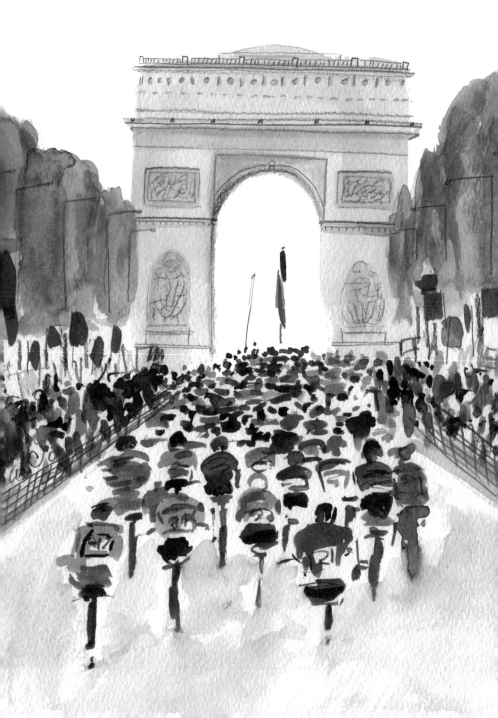

LE TOUR de FRANCE on
LES CHAMPS-ÉLYSÉES

*L*uxury shops and cafés line the wide Avenue des Champs-Élysées, a grand boulevard that runs between the Place de la Concorde and the Place Charles de Gaulle, and ends in a whirl of cars around L'Arc de Triomphe.

Les Champs is also the last leg of the Tour de France, an annual bicycle race that is more than 100 years old. Cyclists from all over the world traverse France's mountains and valleys before arriving in Paris to complete their final lap, around L'Arc de Triomphe. You might see the flash of their jerseys as they speed to the finish.

On July 14, Bastille Day, a flag-lined parade proceeds down the avenue to commemorate the beginning of the Revolution and the storming of the Bastille. The celebrations go into the evening, when giant fireworks illuminate the sky.

LATE-NIGHT REPAST on
LE CANAL SAINT-MARTIN

*T*he Canal Saint-Martin neighborhood has wide shaded banks to stroll along where the water level is closer to the street. Canal Saint-Martin shimmers at night. Under a footbridge by the canal, you can celebrate the end of summer over escargot and "coq au vin" (chicken braised in wine), and enjoy a dreamy "Île Flottant" (floating island) for dessert.

L'AUTOMNE
(Fall)

September marks "la rentrée," when many Parisians return from their August vacations. The metros and streets are packed with rushing people wearing hats and scarves. Graphic posters announce the arrival of the big art shows, lectures, and concerts. The poplar leaves turn yellow, as does the early evening light, and the city sky-line appears black against the golden horizon.

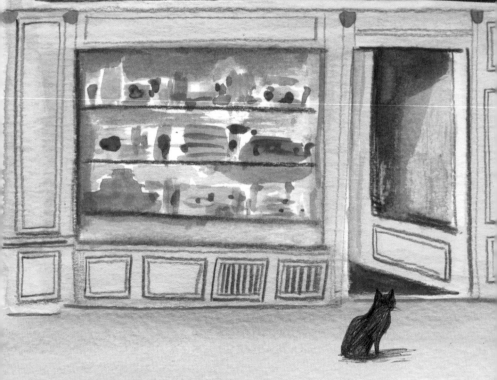

LE GOÛTER

At 4 p.m. on school days, children wearing backpacks line up to buy treats at the boulangeries. An after-school snack (called "le goûter") is most often a "pain au chocolat," but it could also be a "tartine aux pommes," or "petits gâteaux." The baker slips each treat into a thin paper bag, handing it tenderly to each child—many of whom she seems to know. "Merci, Madame!" the children sing.

ROASTED CHESTNUTS

*A*s the days cool, street vendors roast fresh chestnuts. Cooking the nuts over slow fires in tin drums, the vendors turn the nuts, using their fingers, until the nuts char and split. They pack the chestnuts into newspaper cones called "cornets" while they are still hot enough to warm chilled hands.

In French, chestnuts are called "marrons" or "châtaignes." Not only are chestnuts roasted and eaten on the street, they are sugared ("marrons glacés"), pureed into a crème, or covered in chocolate as a special treat during the holiday season.

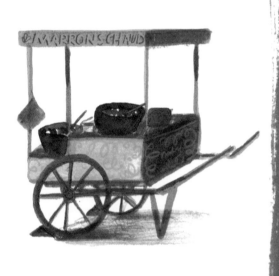

THE MASTERPIECE STAMPS at LE MARCHÉ-aux-TIMBRES

Not long after the first French postage stamp was issued in 1849, stamp collecting became a full-blown craze in Paris. A rich stamp collector donated the Carré Marigny, a lovely shaded square near the Champs-Élysées, to the city as a marketplace. Today, dealers sell rare and beautiful stamps and coins at Le Marché-aux-Timbres.

French stamps are particularly gorgeous and detailed—many depict paintings, sculptures, and art masterpieces. From Renoir to Degas, Manet to Braque, you can create your own miniature art collection.

STUDENTS and CATS
on the RUE de SEINE

On the Rue de Seine, art school students carry portfolios and canvases on their way to the École national supérieure des Beaux-Arts, the most famous branch of the 350-year-old school whose alumni include many great European artists, including Jean-Auguste-Dominique Ingres, Jacques-Louis David, and Henri Matisse.

In the neighborhood surrounding the school, galleries sell antiques, decorative art, African sculptures, and modern paintings, where you can spend a warm afternoon wandering up Rue de Seine gazing at the art. Some of the galleries have their own cats; you might see one stretched out in a window.

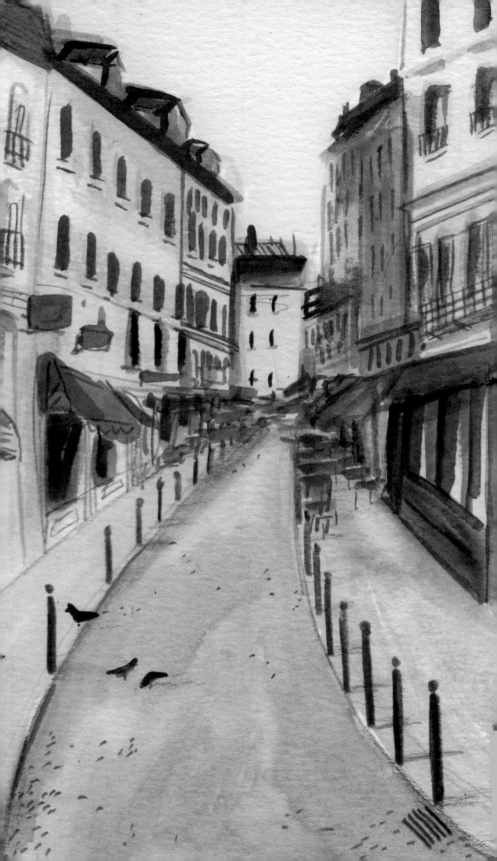

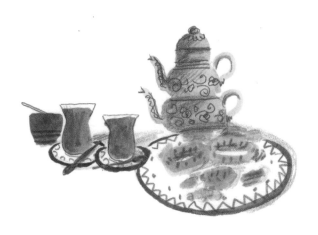

MINT TEA SERVED at the GRAND MOSQUE

*T*he simple streamlined architecture of the Grand Mosque belies the surprisingly lush beauty of its interior. Inside the mosque, a garden with long turquoise pools and tiled fountains invites quiet contemplation. At the café, platters of Middle Eastern pastries dusted in powdered sugar, dripping with honey, are served with glasses of mint tea.

MONTMARTRE on a WINDY DAY

In the nineteenth century, Montmartre was famous for its cafés, dance halls, and cabarets. The most famous was the Moulin Rouge, known to this day as the birthplace of the French cancan. Many artists had studios or worked in or around Montmartre, including Salvador Dalí, Amedeo Modigliani, Claude Monet, Piet Mondrian, Pablo Picasso, Camille Pissarro, and Vincent van Gogh.

The white domes of the Basilique Sacré-Coeur shine brightly in the thin winter light. The stairs of La Rue Foyatier, one of Paris's most famous streets counts 300 steps to Montmartre's summit. On a windy day, the wind blows up the narrow street, rustling the leaves on the trees that line the steep steps.

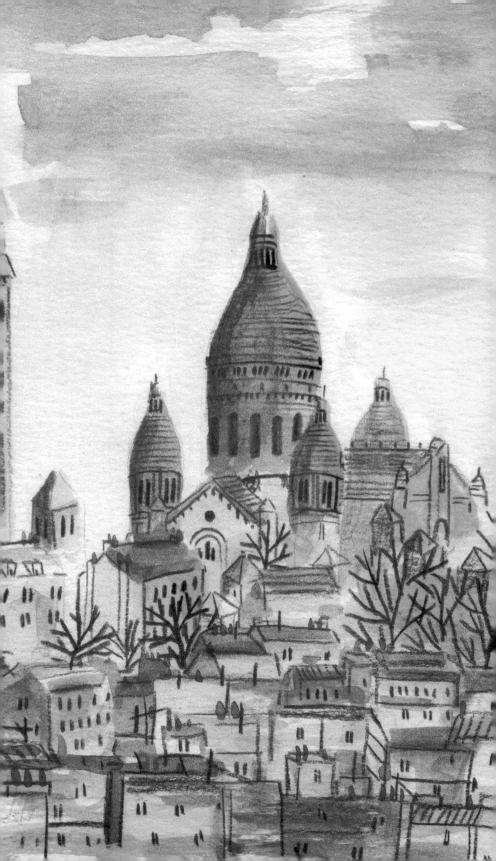

LA GOUTTE d'OR
(LITTLE AFRICA)

*T*o the east of *M*ontmartre, in the eighteenth arrondissement, is *La Goutte d'Or*, also known as *Little Africa*. The neighborhood is home to people from North and sub-Saharan Africa. In the middle of the neighborhood is the *Marché Dejean*, a bustling open-air bazaar filled with exotic fruits, hot chili peppers, and pungent spices. African music permeates the streets. Many of the shoppers wear colorful djellabas and other traditional African clothes.

Nearby you can see African fabrics for sale at the *Marché Saint-Pierre*, a beloved textile market.

THE CLOCKS of the MUSÉE d'ORSAY

The Musée d'Orsay was built in a beaux arts train station that in turn was built for the 1900 World's Fair. Giant clocks, typical of the beaux arts style, frame each end of the museum, harkening back to an era when people traveling through the station needed to be on time.

The sunlit barrel vault of the Musée d'Orsay enhances the sensuality of the art, especially the Impressionist and post-Impressionist paintings whose aesthetics echo the diffuse subtleties of light.

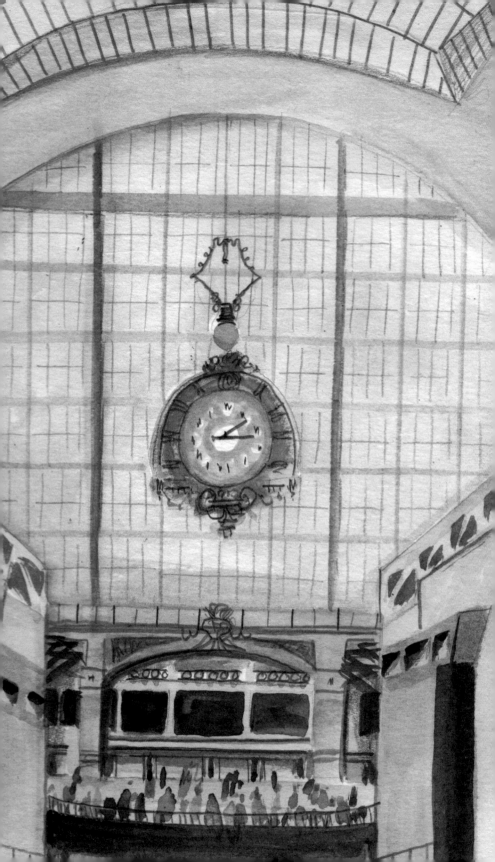

PLACE de FURSTENBERG

*A*t night, glowing streetlights illuminate Place
de Furstenberg, a tiny, secluded square behind
Boulevard Saint-Germain. There you will find
the Musée Delacroix, dedicated to the painter
Eugène Delacroix. Housed in his studio, where
he painted until his death, the walls are covered
with his watercolors, lithographs, drawings, and
souvenirs from a beloved voyage to Morocco.

VINTAGE FRENCH CARS

*I*n Paris, the best time to see vintage French cars is when you are stopped in traffic. If you are lucky you may catch a glimpse of a Citroën, the quintessential French car. The "deux chevaux" (a name that translates to two horse-power) was built in France between 1948 and 1989. In the 1970s, the cars were driven in endurance rallies through deserts.

Another beautiful Citroën is the DS, which was introduced in the late 1950s. Developed by a sculptor and an engineer, it is beloved for its sleek, space-age style.

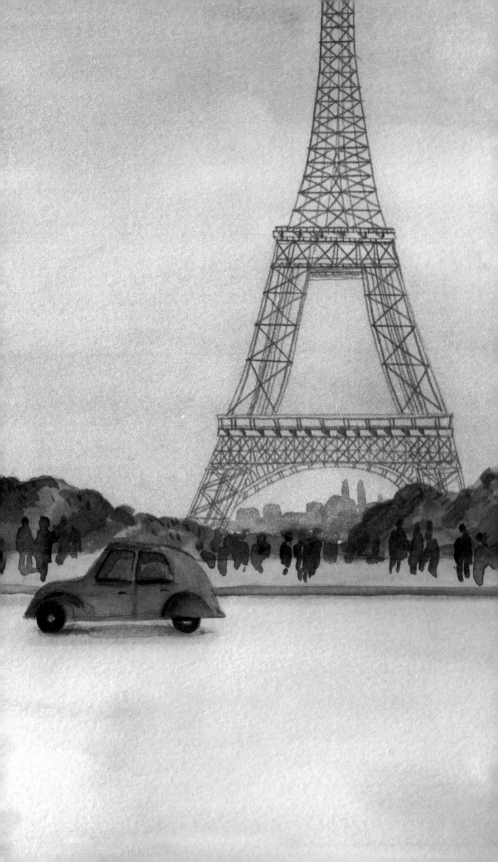

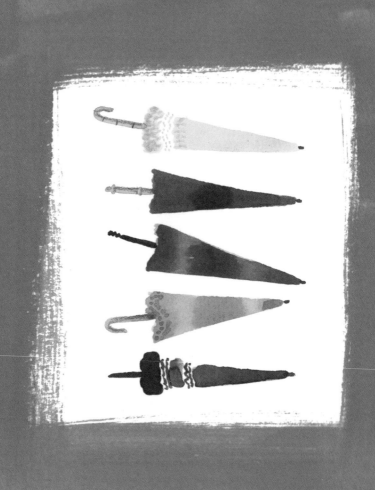

LA PARASOLERIE

La Coulée verte René-Dumont, also known as the Promenade Plantée, are elevated gardens built on the old train line. Below the gardens, the viaduct has been converted into studios, galleries, and boutiques (the Viaduc des Arts).

One shop, Parasolerie Heurtault, sells gorgeous handmade umbrellas made from waterproofed silk, linen, and cotton. Held by a long generous handle, the graceful bell of the canopy is curved and taut, making a low snapping sound as it opens and snaps into form.

L'HIVER
(Winter)

The dark, rainy days of winter are warmed with onion soup, hot chocolate, and "vin chaud" (mulled wine). Paris is illuminated with sparkling holiday lights on monuments, in the streets, and around twisted branches throughout the city.

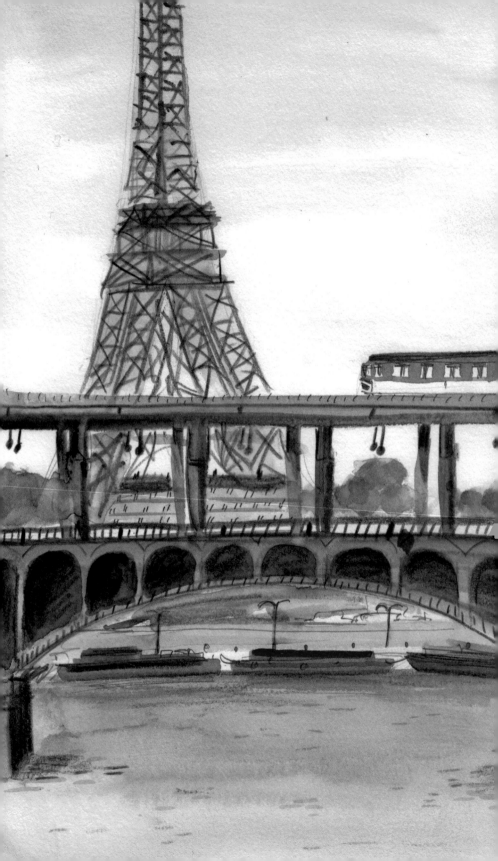

EARLY MORNING
on the MÉTRO

*L*ine 6, one of the sixteen lines of the Paris Métro, follows a semicircular route around the southern half of the city, above boulevards formed by ancient city walls running between two stops, Charles de Gaulle – Étoile in the west and Nation in the east. Because most of the tracks run aboveground, you can see slate rooftops and second-floor windows as your car travels along the rails. On early winter mornings as the train crosses the Seine you can see the Eiffel Tower reflected in the river's still, cold waters.

THE GARGOYLES
of NOTRE DAME

A medieval legend says that a fierce dragon, "La Gargouille," once lived under the Seine and ate ships as they sailed past. According to the tale, St. Romanus, the Bishop of Rouen, slew the dragon and burned its body at the stake. The dragon's head and neck were later mounted on the town wall, and this symbol became the model for gargoyles all over France.

The word "gargoyle" comes from "gargouille," an old French word for "throat." True gargoyles were carved around the bottom of drainpipes to "spit" water when it rained. At Notre Dame, 422 narrow stairs wind up the tower to a landing filled with gargoyles and chimeras—another mythical creature which is a combination of beast and man.

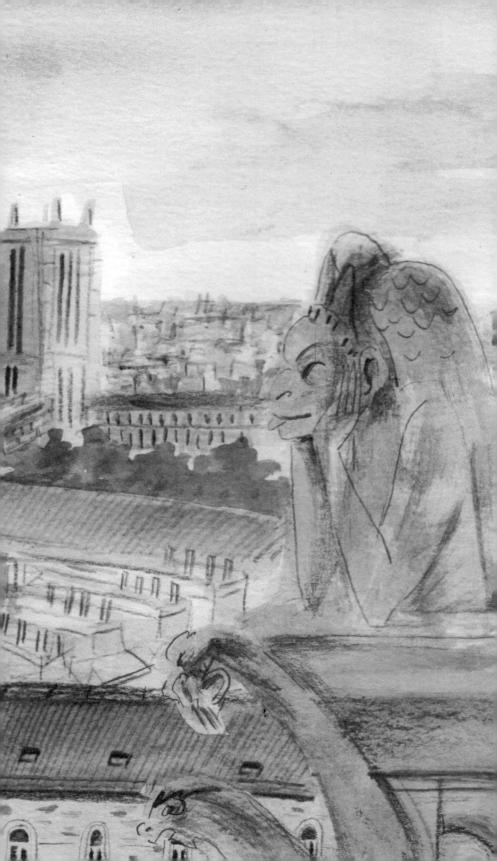

LOOMERS at
LA MANUFACTURE
des GOBELINS

Sumptuous tapestries designed by famous French painters line the entrance to La Manufacture des Gobelins, the once-royal tapestry factory. King Louis IX purchased the factory in the seventeenth century to create tapestries for the Château Versailles.

Today in the tapestry workshop, weavers sit behind giant looms. Though the designs they weave are by contemporary artists, the weavers still use traditional techniques and materials—warping and wefting wool, cotton, silk, gold, and linen. Carefully and patiently, the weavers tie tiny individual knots and pass shuttles back and forth. They sit behind the looms quiet and shadowlike, their fingers poking through the threads.

ICE SKATING at
L'HÔTEL de VILLE

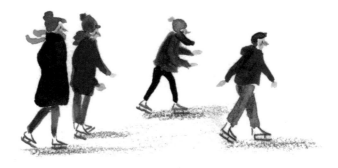

*I*n the winter, ice rinks pop up all over Paris—the most popular is at *L'Hôtel de Ville (City Hall).* Even if it is a gray, snowy day, Parisians bring their children to skate, spin, and pirouette on the famous rink.

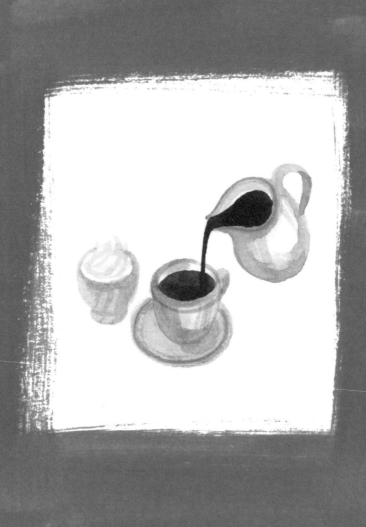

HOT CHOCOLATE at
CAFÉ ANGELINA

*N*ot far from the Louvre, on the Rue Rivoli, the Angelina teahouse serves macarons, madeleines, and the house specialty: Mont Blanc, a dessert made with meringue and chestnut paste. The bakery also makes a spectacularly tall wedding cake out of stacked cream-puffs.

*W*ithout a doubt the best way to warm up on a winter's day is with a cup of Angelina's hot chocolate, served in a white pitcher with a tall cone of whipped cream on the side.

JULES VERNE CAROUSEL
at PARC MONCEAU

*P*arc *Monceau features a collection of follies—life-size, landscaped reproductions of places around the world a garden of the imagination where you can visit a miniature Egyptian pyramid, a Roman colonnade, antique statues, a pond of water lilies, a farmhouse, a Dutch windmill, a temple of Mars, a minaret, an Italian vineyard, an enchanted grotto, and a gothic building serving as a chemistry laboratory.*

The surreal scene is heightened by a carousel of fantastical creatures named in honor of the French visionary writer Jules Verne. In the winter, small, bundled-up children escape to imaginative worlds aboard the exotic woodcarvings of a giraffe, a fire engine, and a spaceship.

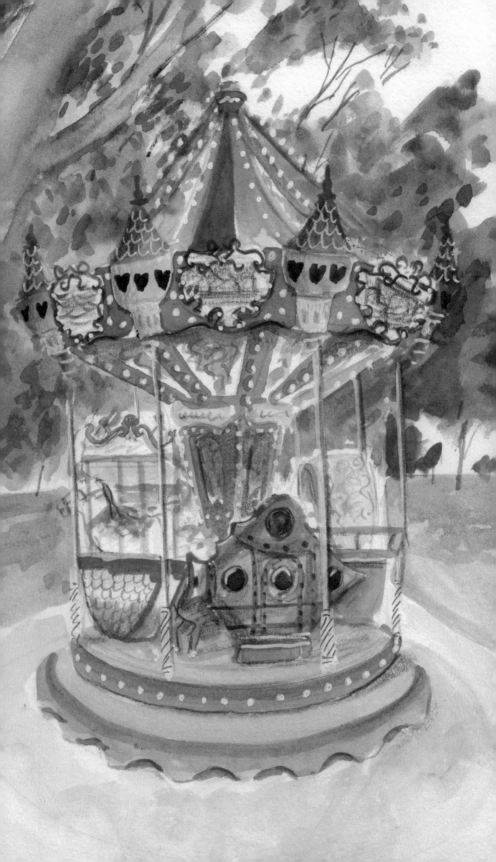

ANTIQUE KEYS at the FLEA MARKET

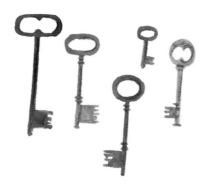

*T*he flea market shops at St. Ouen are filled with botanical drawings, miniature cars, antique clocks and scales, copper pots, broken chandeliers, vinyl records, porcelain teacups, and most intriguing of all, collections of skeleton keys pinned on corkboards. The keys come in various sizes, tarnished and rusted with the passage of time. Looking at them, you might wonder what doors they once unlocked.

OYSTER PLATES at LA COUPOLE

*L*a Coupole in Montparnasse is the grandest of grand Parisian brasseries. Its art deco dining room is filled with long tables draped in white linen; its walls are antique mirrors. Beloved by artists and writers of the Lost Generation, it is said that Picasso, Jean-Paul Sartre, and Simone de Beauvoir came here to drink and people-watch.

Brasseries are open throughout the day until very late at night, serving traditional French cuisine. Winter is the height of seafood season in Paris. A large outdoor trough of ice holds a giant bar where you can order huge crustacean platters of oysters, periwinkles, and shrimp.

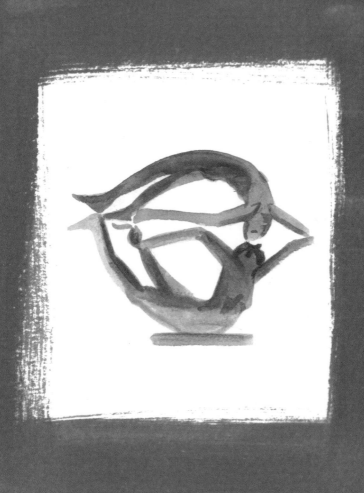

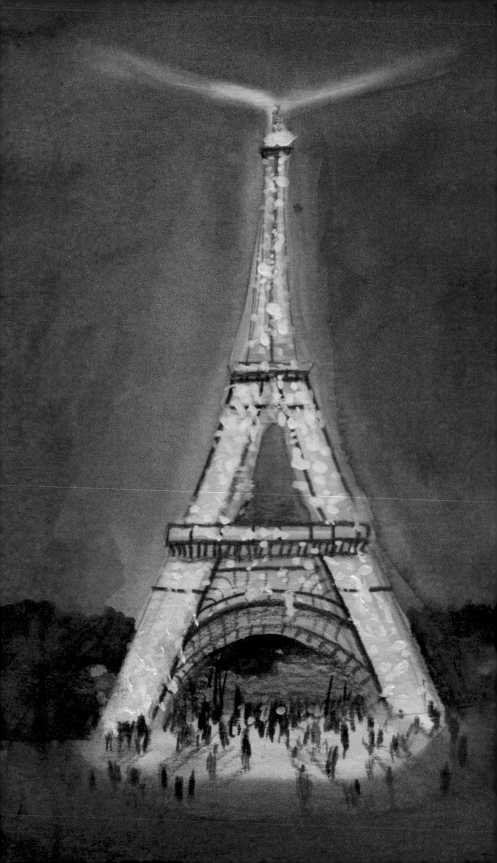

PARIS by NIGHT

The Eiffel Tower glitters throughout the night, standing tall above sleeping Paris. During the holidays, lights and festive decorations appear across the city. Strings of white lights are entwined on the trees along the boulevards.

At the Place de la Concorde, the Grande Roue ("big wheel") turns slowly in the central square. You can ride it at night and see the twinkling lights all over Paris cutting through the night sky.

LA FÊTE des ROIS

*I*n early January, you might see people wearing gold paper crowns all over the city—in the streets or on the Métro—for La Fête des Rois, or Three Kings Day. Bakeries sell "la galette du roi" (the "king's cake"), a decadent pastry filled with almond paste. Each cake has a plastic "fève" (charm) baked inside. The lucky person who finds the charm gets to be king for a day!

ACKNOWLEDGMENTS

One of the greatest pleasures in life is collab-orating with lovely people. I wish to thank my editor, Bridget Watson Payne, for her kind support and insightful vision for this book, and editor Rachel Hiles for her thoughtful line editing and kind, gentle guidance throughout the writing and editing process. I would also like to thank my family, especially my parents, Arthur and Suzanne, who take pleasure in all things and whose generosity of spirit inspires me daily.

ADDRESS GUIDE

1ST ARRONDISSEMENT:

· Sainte-Chapelle
 S Boulevard du Palais, 75001

· Le Jardin des Tuileries
 113 Rue de Rivoli, 75001

· Le Palais Royal
 S Rue de Montpensier, 75001

· Champs-Élysées
 Avenue des Champs-Élysées, 75001

· Musée du Louvre
 Musée du Louvre, 75058

2ND ARRONDISSEMENT:

· L'atelier de l'Éclair
 16 Rue Bachaumont, 75002

4TH ARRONDISSEMENT:

· Le Marché aux Oiseaux et aux Fleurs
 (The Bird and Flower Market)
 Place Louis-Lépine, 75004
 SUNDAYS ONLY.

· Notre Dame de Paris
 6 Parvis Notre-Dame, Place Jean-Paul II, 75004

· Les Bouquinistes (The secondhand booksellers):
 Along the Seine near Notre Dame

- Beaubourg/Centre Georges Pompidou
 Place Georges-Pompidou, 75004

- La Fontaine Stravinsky
 Place Igor Stravinsky, 75004

- Place des Vosges
 Place des Vosges, 75004

- Berthillon
 31 Rue Saint-Louis en l'Île, 75004

- Hôtel de Ville
 Place de l'Hôtel de Ville, 75004

5TH ARRONDISSEMENT:

- Marché Mouffetard
 116 Rue Mouffetard, 75005

- Grand Mosque
 2bis Place du Puits-de-l'Ermite, 75005

6TH ARRONDISSEMENT:

- Les Deux Magots
 6 Place Saint-Germain des Prés, 75006

- Luxembourg Garden
 6e Arrondissement, 75006

- Rue de Seine
 Rue de Seine, 75006

- Place de Furstenberg
 6 Rue de Furstenberg, 75006

- *Musée National Eugène Delacroix*
 6 *Rue de Furstenberg*, 75006

7TH ARRONDISSEMENT:

- *Musée Rodin*
 79 *Rue de Varenne*, 75007

- *Musée d'Orsay*
 1 *Rue de la Légion-d'Honneur*, 75007

- *Le Champ de Mars*
 2 *Allée Adrienne Lecouvreur*, 75007

8TH ARRONDISSEMENT:

- *Les Bateaux Mouches*
 Port de la Conférence, Pont de l'Alma, 75008

- *Le Marché-aux-Timbres*
 Carré Marigny, 75008
 THURSDAYS, SATURDAYS, AND SUNDAYS.

- *Parc Monceau/Carrousel de Jules Verne*
 35 *Boulevard de Courcelles*, 75008

9TH ARRONDISSEMENT:

- *Galeries Lafayette*
 40 *Boulevard Haussmann*, 75009

- *Paris Opera House at Le Palais Garnier*
 8 *Rue Scribe*, 75009

- *À la Mère de Famille*
 35 *Rue du Faubourg, Montmartre*, 75009

10TH ARRONDISSEMENT:

- Canal Saint-Martin
 Quai de Valmy, 75010

12TH ARRONDISSEMENT:

- Parasolerie Heurtault
 Viaduc des Arts, 85 Avenue Daumesnil, 75012

13TH ARRONDISSEMENT:

- Manufacture Nationale des Gobelins
 42 Avenue des Gobelins, 75013

14TH ARRONDISSEMENT:

- La Coupole
 102 Boulevard du Montparnasse, 75014

18TH ARRONDISSEMENT:

- Marché Dejean
 2 Rue de Suez, 75018

- Montmartre
 Montmartre, 75018

- Marché aux Puces de Saint-Ouen
 (The Paris Flea Market)
 99 Rue des Rosiers, 75018